MANCUNIAN WAYS

Compiled and edited by Isabelle Kenyon

First published October 2020 by Fly on the Wall Press

Published in the UK by

Fly on the Wall Press

56 High Lea Rd

New Mills

Derbyshire

SK22 3DP

www.flyonthewallpoetry.co.uk

ISBN: 978-1-913211-28-8

Copyright © 2020

Typesetting and cover design by Isabelle Kenyon. Cover photo-Cheryl Pearson.

Supported using public funding by

ARTS COUNCIL ENGLAND

LOTTERY FUNDED

Letter from the Editor:

When I first posted the call out for the Mancunian Ways Anthology, I was apprehensive. I had hoped to find photography, art and poetry to reflect all that makes the city of Manchester special, but was uncertain that its unique culture, history and ATTITUDE could be conveyed by one book. But the people of Manchester did not let me down: their passion for the city and their creativity ooze from every page.

There is pain within. Estelle Price remembers the 15th of June 1996 bombing (the time and day of my birth); Marie Naughton recalls the Suffragettes and Moss Side-born Emmeline Pankhurst. But there is also resilience ('This is my Tribe', Jan Berry) and joy (from the Hacienda, to the Ritz to The Gay Village). Here you will find roaring sports fans alongside quiet celebrations of culture and snatched moments in those hipster coffee shops we secretly love.

Our city has been hit hard by COVID19. Even our chosen launch venue, the Nexus Art Cafe, has closed down, and the Arts suffer financially across the board. While it is a strange time to launch a book, it is an important one. A time for artists to write and create more than ever. If we can't meet in person, we must put pen to paper to be heard.

To the Mancunians - I hope this is a book to be proud of. A bit of northern grit goes a long way. A special thanks to Lemn Sissay for allowing the publication of some of his Manchester building poetry, and to Jackie Hagan for her gorgeous commissioned poem.

With love,

Isabelle Kenyon

P.s. To the Manchester United fans - we couldn't find you a poet representative!!

Maybe you can write one for us...

Contents

Northern Dream

Let There Be Peace, Hardys Well, Lemn Sissay 8

Millenium, Tina Tamsho-Thomas 11

Ch'ang-kan comes to Manchester, Ruth Aylett 12

On this hot May afternoon, Elizabeth Gibson 14

Long Distance, Abbie Day 15

A Manchester Love Story, Reshma Ruia 17

Manchester - Outer and Inner, Peter Viggers 20

To the Edge, Olga Kenyon 22

Modern Manchester

FAC-51, Billy Morrissey 24

Rough Sleeping in the Second Richest City, Charlotte Murray 26

Manchester, Olivia Walwyn 28

City Derby, Second Leg..., Lou Crosby 30

Maine Road, Lee Garratt 32

Reds and Blues, Dave Williamson 34

Ascension, Joseph Darlington 36

City of Cranes, Sarah Pritchard 37

Hale-Bopp, Victoria Gatehouse 38

Northern Spirit

The Ladies, Manchester Victoria, Victoria Gatehouse 40

The Ritz, Vicky Morris 42

Before the Village, Sarah Pritchard 43

Arrival, Elizabeth Gibson 45

My Tribe, Jan Berry 46

Rain by Lemn Sissay 48

Lunch hour - Sackville Gardens, Cheryl Pearson 49

Manchester Tram, Alicia Fitton 50

Praise for the evening commute, Cheryl Pearson (Poem), Albert Square, China Town, 52
Library Walkway, (Photography) Cheryl Pearson

(Photography) Beverley O'Donoghue 57

Cigarette Break, Bowie Tribute, Golden-Booted Cowboy, (Photography), Nikki Culley 58

Almost a Beanstalk, Wasteland of Light, Ghosts… (Photography), Penny Sharman 60

Artwork, Lisa O'Hare 64

(Photography), Beverley O'Donoghue 65

Mancunian History

The spirit of Manchester, Estelle Price 70

Before The Dual Carriage Way, Tina Tamsho-Thomas 72

i.m Sunny Lowry, Cheryl Pearson 74

Tony Wilson's Dream, Benjamin Cassidy 75

The Blanket Bundle and the Marsh Gas Man, Kathy Zwick 76

Suffragette Tree, Marie Naughton 79

Northern Grit

Spiced, Rob Whitworth 82

Standard Fare, Linda Goulden 83

City Tour, David Keyworth 84

It was such a nice sunny day, Estelle Price 85

23_05_2017, David Keyworth 86

Something in the water, Rosie Garland 87

The Portico, Victoria Garland 91

the war of each against all, is here openly declared (engels), burn 93

Northern Culture

It takes a woman to know a woman, Estelle Price 96

Eighth Day Café, Sarah L Dixon 98

Photograph of Lowry at Home, Ruth Taaffe 100

Sounds imported from up north, Sam Rose 101

Oh ManchestOH, Fiona Boylan 103

After Lowry: 'Laying a Foundation Stone' (1936), Ruth Aylett 105

Bubble gum pavements, Mark Andrew Heathcote 106

Central Library, Susan Sollazzi 107

Last Orders

Oxford Rd, Jackie Hagan 110

NORTHERN DREAM

Let There Be Peace

By Lemn Sissay

Let there be peace

So frowns fly away like albatross

And skeletons foxtrot from cupboards,

So war correspondents become travel show presenters

And magpies bring back lost property,

Children, engagement rings, broken things.

Let there be peace

So storms can go out to sea to be

Angry and return to me calm,

So the broken can rise up and dance in the hospitals.

Let the aged Ethiopian man in the grey block of flats

Peer through his window and see Addis before him,

So his thrilled outstretched arms become frames

For his dreams.

Let there be peace

Let tears evaporate to form clouds, cleanse themselves

And fall into reservoirs of drinking water.

Let harsh memories burst into fireworks that melt

In the dark pupils of a child's eyes

And disappear like shoals of silver darting fish,

And let the waves reach the shore with a

Shhhhhhhhhhhhhhh Shhhhhhhhhhhhhhhhh Shhhhhhhhhhhhhhhh

Hardys Well

By Lemn Sissay

Wait waterless wanderer. Whoever walks

To the Well will wade into a wonderous world.

A world which will waken the wilting

Wallpaper of work and worry. Well? Worry

Will wait while Wells wand whirls a warm –

Hearted wackiness into a weary week.

Whereafter waves and waterfalls of

Wonderment will wash all weakness. A way?

Well? A world wide web of wholehearted

Wholesome wisdom and wit waits wipe away

worries. Wells works wonders for wrinkles.

Why wait. Why wonder. Why worry. Why

Wain. Why whittle. Why wither. Walk in. Well.

What we waiting for. It'll double you. At

Hardys Well.

Millennium

By Tina Tamsho-Thomas

Manchester- linked by Metro lines,
football teams, urban regeneration schemes
and music dreams are made of.

Ancient mills and warehouses
host all night raves, where *Ecstasy*
extends night into day and in the morning
manufactures nightmares.

City of commerce and business-like
relationships, cleaned canalways, café society,
alfresco with attitude, unless unemployed,
undervalued and homeless.

Manchester - city of enterprise,
entrepreneurial drive, traffic-free zones,
broken homes, pipe dreams,
regeneration schemes.

Welcome to the Millennium.

Ch'ang-kan comes to Manchester

By Ruth Aylett

After Ch'ang kan Village Song, by Li Po

My bubble perm was still new then
I sat on our front step messaging my mates

You pulled up on your new mountain bike
in unscratched silver, did casual wheelies

We both lived here in Wythenshawe
both restless, wanting something different

Only fourteen; you said you were *The One*
but I was sure a better bloke would come along

Mouthed off at you, texted my mates sneers
ignored your smiles, pushed off embraces

But the very next year my heart crumbled
and suddenly, I couldn't live without you.

You told me you were Mr. Dependable
not dropping me suddenly if I got pregnant

Then, a summer later, you went to be a squaddie
allocated to the second Iraq tour of duty.

The summer smog turned the sky blank
and the estate echoed to stolen cars at night

We stood for more than an hour on the front step
and I drew a black marker line round your feet

Today, dust scours it away as I brush the step clean
and late August is already autumn, leaves fall

Into September. Two red admirals jostle
on the waste ground willow herb, stick together

and it hurts. When I look in the mirror
I see some worn-out, heart-sick stranger.

Before you come back from Baghdad
or wherever, send a text or an email

But don't think I'm coming down south to meet you.
No further than the train station at Piccadilly.

Ch'ang-kan Village comes to Manchester was first published in Ofi Press 62, April 2019, p8

On this hot May afternoon
By Elizabeth Gibson

On this hot May afternoon, you make fun
yet again of our yellow trams,
tell me there is no point to them.
You live – lived – in Rusholme, land
of buses, classes, student residences,
squirrels and magpies, curry and doughnuts.

You never came with me to the Ship Canal
at Salford Quays to see the Canada geese,
or to Chorlton to eat halloumi burgers,
see cherry blossom and a possible future.
Now we are on our final journey,
to Piccadilly Station, to your train.

I will help you with your bags, books, plants,
all the random stuff that a student acquires.
I will bluff my way onto your platform
where we will awkwardly hug.
I will notice how green your eyes are
and wonder if we look like a couple.

Long Distance

By Abbie Day

Recently, I've not been coming round to visit.

Instead, I stuff my suitcase with excuses

it has been too long and I am always misremembering us,

the clumsy firsts of youth we spent together

when you watched me gut the house of my possessions,

when I'd finished, and my life without you fitted into a car boot,

I thought you seemed upset.

Or maybe I imagined my profile

in the Manchester Evening News:

Another Millennial Leaving Town

to pursue big dreams in the big smoke

an unfamiliar Piccadilly, a different O2.

Manchester,

I miss you more than I thought it was possible

to miss an industrial skyline;

when I read your name in train stations

I turn away to stop myself checking the platform number.

So when I see you in the news,

your face painted with suffering and resilience

I think God —

I miss this *Wonderwall* city of mine.

Tony Walsh's voice declares This Is The Place

through the speakers in Euston station

and London nods along in sympathy.

It hits close to home to be so far from you,

to feel a stranger in my anger at those who invade

the places I associate with childhood

and make them feel unsafe.

And when I talk,

I feel the vowels expand;

slipping accents are inevitable

but I have London's tube lines tattooed across my speech,

I am better at directions here

and using Northern phrases has begun to feel like stealing.

I don't call much these days.

You are a distant acquaintance who has suffered a loss

and it is no longer my place to comfort you;

I tell myself it would be disingenuous to try.

I called you last week,

No one picked up.

A Manchester Love Story

By Reshma Ruia

The scent of love is the smell of chips on your fingernails, vinegar-doused,

eaten hunched together outside Leo's fish bar,

the sky above pinpricked with slate-grey Manchester rain.

You have left your umbrella on the tram somewhere between Altrincham

and Trafford Park

but it doesn't really matter

for now you have this glorious stretch of day,

unrolling like a red carpet at a movie premier.

'What shall we do next?' you ask, your eyes saucer-eyed with longing and lust

and he replies - *how about taking a turn at the Whitworth Gallery,*

I heard there are 20,000 textiles from across the world.

Bolts of brocade and silk that whisper of Britain's Imperial past.

'Yesss…' you say, slipping your damp hand in his,

'history can sometimes be cruel.' You walk towards the museum café

swinging from the trees of Whitworth Park.

'Their soups are exceedingly good,' you tell him, your mouth hovering

over the cream bowl in which swim tomatoes the colour of blood-red sunsets.

Outside the giant-sized windows, the tall trees undress with cheerful abandon,

shedding their leaves, slipping out of their skin with practised ease.

Winter will soon be here

But you don't really care. You have him.

After, you will wander hand in hand; stare at portraits of long-dead cotton barons

that once made this city great.

'There, that's him,' you point to the pale-pink man, his lips pleated in a smile.

'Samuel Greg. He built Quarry Bank Mill on the banks of the River Bollin.'

You feel like a child showing off your favourite toy.

What next? he asks. *My train doesn't leave till half past late.*

You drag him to where Engels stands, tall and proud, broken and put together again

on the long, long ride from Ukraine to Tony Wilson Place.

'HOME's right there, let's watch a film. They have a season of Brazilian Noir

and the director is coming along for a chat.'

Home - is this an invite of sorts? he asks, the corners of his eyebrows rising up in pleasured surprise.

'HOME is much more than home,' you explain,

'We can sip cocktails; catch a movie or a show,

dream our lives away in plush red seats, glass of vino

and popcorn in hand.'

Sounds like my kind of place, he says,

flinging a careless arm around your shoulder.

You are trembling, but it could just be the cold.

The day refuses to end or maybe Manchester is just kind to lovers.

The sky wiped clean of rain, throws a blue, toothy grin

as you make your way to Rusholme, past

laughing students strolling, satchels slung on their backs.

Fairytale string lights wink from wholesale spice sellers

and shisha smoke smudges the kohl in your eyes.

There will be mango lassi and platters of kebab and

Biryani cooked just the way you like it.

There is a carnival of taste inside your mouth, you giggle

when he leans forward to flick away

the grain of rice stuck to your cheek.

Happiness suits you, he says as

you gift-wrap your city for him to take back.

Manchester – Outer and Inner

By Peter Viggers

Friday night and we take off from our friend with her patchouli candles
and kundalini postures, looking for enlightenment, down tree-lined avenues
toward the city centre. Reflected in windows we flicker through leaves,
past portico doors and in-car sound systems, booming dubstep and hip hop.
Darkness slows the suburb's life, hidden behind Accrington bricks
and herringbone drives, homes calm during lengthening nights,
stoves bubbling with white bean soup or haddock. A time perhaps
to curl up with Kristeva, or avoid irritation and be soothed by beard oil.

A narrow boat is stuck in the Ashton canal as we reach the Northern Quarter.
The canal, once blocked with sofas and a toxic sludge of solvents and oxides,
is now a desirable location, though non-residents sit patiently waiting for fish;
grandsons perhaps of barrel piano makers and ice cream factory workers,
gone the glass factories, cotton mills and textile machinery makers;
gone the balaclava-clad men unloading contraband into warehouses at three a.m;
gone the days Manchester was bleak and *Joy Division* called themselves *Warsaw*.
This evening it is lattes and cappuccinos on balconies, as Canadian geese
swan by, expressing a need for bread, even if it is gluten-free.

Is Manchester wet? Not tonight, only the merest trace of breeze
wafting aromas of coffee and hash, the promise of plenty
for lips and mind, our noses lead us to a world that yields.

It is the time of year when arachnids with attitude hang around the scene

of their kill and dare you to mess with their webs

and poetry is read in half-renovated pubs to the bearded, tattooed,

bespectacled and us; no longer feeling provincial, feeling

in touch with the full moon and touched by a fig tree

in an undersized pot. We might find something new here, no need

to look out there, find something we can't quite name, shimmering

way beyond Beetham tower, the boondocks forgotten, the candlelight

flickering around us, here by the red bricks and old floorboards laid bare,

where no one - not even Peter Barlow - smokes cigarettes; those

chemical traces, linger like ghosts.

To the Edge

By Olga Kenyon

We take the train, one sandwich, one poem each

and stomp, the silent physicist and me,

past footballers' mansions, gnarled roots, car-park,

with a few walkers gazing at emptiness,

and trudge to the vertiginous edge.

We clamber over prehistoric boulders

to the solitary carved wizard stone above

a real world of corn, brown - and green.

Our minds open out over the sheer drop,

track a bird soaring up into blue wind

and watch laws at work:

stages of flight, breaking free.

Trees, corn, earth appear a kind of falling.

Suddenly, I'm no weight, just a point

of view.

(North West Libraries Poetry Prize Winner 2013)

MODERN MANCHESTER

FAC-51

By Billy Morrissey

And if true sadness exists

you'll never find it here

as we *dance dance dance*

in the Hacienda's laser beam heaven.

Girls and boys,

girls who like boys who like boys who like girls

and those that don't really care,

skirts go up

and hands go down

breathing in the Deansgate air.

Pillars of yellow and black

with the energy of the night like

heroin

injected into your veins

lights flash in neon hues

the raves go on for days.

Graffitied toilet doors

smashed corners of bathroom mirrors

all tell the tales of this factory of desires

break ups, best friends and all the drunken Mancunian liars

Forget the Leadmill, South or 42s

they haven't seen what FAC-51 could once do:

All those girls 8 hours pregnant

whose mums are gonna kill 'em

the shaved heads and

the rave heads

that parade the fluorescent village streets

Smiths, Roses, Happy Mondays.

The building now stands vacant

of the brightly-coloured nights

but the ghosts of the cellar

remain dancing into forever.

Rough Sleeping in the Second Richest City
By Charlotte Murray

Newsstands scream

 CLEAR THE STREETS

bright carrier bags sleep against

 silent, age-old sentries

 with faces of stone.

 Rustling cave of warmth, the only roof willing

to offer protection from the clouds' cold pearls

of rage

 daughter's road-weary stuffed toy, threadbare

with embraces

 lone reminder of crenellated memories

 lines of ink charting the last safe paths to oblivion, woven

with the whiff of a different world

 the *accumulated detritus* of a life

suspended between thumb and forefinger at arms' length

swept and scraped into an airless tomb

 you can keep your coat.

Wildness in the purple moons of eyes

 speaks of roots ripped from the earth

but the words fall into the same fault line

 as all past cries for help.

Shopping bags swing by

 eye contact racing to get away

 visibly and persistently indifferent.

Animated voices speculate for well over

 half an hour on

 what colour will it be? Does it have a touch screen?

now tell me again how material things don't matter.

Shrouded in a torn mantle of red, white and blue

 in that ancient hidden chamber between

 department store walls

 shuddering and blistering in the *unfavourable light*

 of contagious misfortune

a foot in the face in haste

 for the next train

 counting the metallic tang of change

 hoping there's enough to get through the next day.

Manchester

By Olivia Walwyn

It shrinks you to a comfortable size

as you stroll beneath its clean, tall buildings –

'pismire'-ised. Out of sight

of the sun, near always, except

when it stoops low, near the end of the day

and peers around the blocks, like a giant

sorting through his rows of books –

looking for the right one.

If he lights on you, it's lucky: like

he's got his torch out, late at night

to read, and stumbles on you,

finds you like the right place. You blush.

But it's always at a kind angle –

a glance across a table, not direct –

as if he paused, between one lift

of his pint glass and the next.

You can sit on the base of a statue

and swing your legs. No one will notice.

They will just take it all in —

like you're a person in a painting;

matchstick, part of the scene.

Note. 'Pismire,' a dialect word for an ant, first encountered by the author in the poetry of John Clare.

City Derby, Second Leg (January 2020)

By Lou Crosby

It's the squash on the tram, checking for scarves.
Talking to rivals. The walk in the dark.

It's joining the march, all decked in sky-blue.
The glow from the roof that leaks to the sky.
It's burger bar steam, pint pots stacked high.
Orange-clad stewards. Selfies with mascots.
Criss-crossing fans, all going the same way.

It's finding the gate and waiting in line.
The arms out search, tall turnstile squeeze.

 Endless corridor of open coats.

Betting slips and bars, loud pundits on screens.
Hot dogs and ketchup, meat pie and chips.

It's the glimpse of blue seats, flashes of green.

Finding the aisle, stepping down to the row.
Counting the seats, the shuffling along.
Nodding to neighbours, checking the view.
The rows of faces, lit up by the glow.

 The floodlit emerald jewel.

It's the single word, that starts off a chant.

It's the single note, a head-thrown-back song.

The clapping in time. The oath 'til we die.

For City stand up, arms high for *Hey Jude*.

The away fans' chants, drowned by *Blue Moon*.

A rise for the team, clapping each name.

Loud tannoy song, taken by the crowd.

First whistle a cheer, a boo for the next.

Screaming opinion, shouting at the ref.

Each corner applause, each lost ball a groan.

Following the play, tracking each move.

 The willing

 the stop breathing

 the gasp

 the head grabbing moan.

 The clapping, more cheers, repeating the songs.

 The shout for a pass

 the stadium on their feet

 the leap for a goal

 the r o a r

 silenced by VAR.

It's the losing, but knowing we're through.

It's the analysis, all the way home.

Maine Road

By Lee Garratt

On winter nights you'd take me to the football.

Through dark, terraced streets huddled in their ruins

beneath the floodlights, wrought iron hammered by men and bent to the sky.

Inside, piss and beer puddled the concrete,

Chanting voices ebbed and roared.

I watched a far-off fight, the crowd parting, then surging, like seaweed in the surf.

Then home, the metronome of windscreen wipers, rain battering the glass.

To grow old is to slowly become a stranger.

An old woman drifts past unseen,

still hearing the piano,

voices raised in song.

The tide went out a long time ago and never came back.

She walks through what wreckage is left, sifting the flotsam for anything old, anything old.

I still go to the football sometimes.

Buy my ticket online,

then sit, thousands strangely muted,

watching rich, young foreign men kick a ball.

Above, the skies darken and it rains, and, as I walk away,

oil slicks the pavement, rainbows form in the gutter,

'till finally, in the cracks of the city,

the Millstone, the Unicorn,

I wash up, battered and gasping.

Then, the floor still heaving beneath us,

we sit round the fire and share our stories,

clinging to the past, clutching to our pints.

Originally published in 'New Worlds' (Dimensionfold publishing, 2020) and magazine 'We only want the earth'.

Reds and Blues

By Dave Williamson

Red shirts in the distance. Knotted scarf and white skinhead
Eighteen-hole Doc Martins, all done out in cherry red.
Watch your step if you're a blue, or they'll kick you 'til you're dead.

Never only one of 'em, drunk an' roaring footy chants
Always come mob-handed, cap sleeve shirts and turned-up pants.
Always bloody more of 'em....just an army of red ants.

Tattoos, beer and ciggies are the order of the day
And they'll kick your bloody head in if you get in their way
Don't care if it's midnight, or the middle of the day.

If you're locked up for an hour and you've thrown up in the van
And the black Maria's stinkin' of sour vomit from your can
You can rub your eyes next morning and call yourself a man.

And when you see the judge and get a bollockin' and bail
See your mates at the pub that night and tell 'em your tall tale
You can puff your little chest out and call yourself an alpha male.

But later, when you're older and want to earn a wage
And employers see the tats and scars, then turn to the next page
To find a bloody job now, takes a bloody age.

And your past creeps up and haunts you, just like Jacob Marley's ghost
And you wish for a job offer, in every morning's post
If the red devil on your arm is the proudest thing you boast.

I remember all the rantin' and the chantin' through the town
And the chasing and the hiding, as the bastards ran me down
And the kickin' and the bleedin', the missing tooth that's now a crown.

Well, good luck to you, you skinhead, I'll remember you one day
When you turn up for an interview and I turn you away
Payback's always sweeter when a blue sky comes your way.

And now we're all damn skinheads, as we're bald as bald can be
It won't matter if you're red or blue, we love football, we agree
It's just a shame that you weren't born a City fan, like me.

When you get to heaven and St. Peter picks you from the queue
And sends you down to Satan, to join his motley crew
Bet you wish you'd known that God, wore a shirt that was sky blue.

Ascension

By Joseph Darlington

They rise, mountains on mountains
Shimmering steel, bolts blasted
And glass running a liquid
Skin across the city's new,
Rain-sparkled bones. Uplift our
Tangled thoughts on cranes' red dots
And shatter open the sky.

Here is the new Manchester,
Racing, leapfrogging itself,
In a race to catch the sun.
A race dead earth shall envy.
A race for the gold of morn.

Do they know, ever higher
Ever higher, what above
Calls to them? Or do they flee
The roaring, monstering ground?
Only race, blind, bumbling bees
Hum skywards, racing towards
The very last sip of sky.

Those left behind are buried
All meaning has ascended.

City of Cranes

By Sarah Pritchard

This bird needs space.

He is alone as he climbs the ladder cage

The tallest of legs, the widest of wings

It can take him 15 minutes.

She needs safety, no disturbances to nest.

He must take all the food he needs with him.

She's an omnivore, will feed on nearby insects, small mammals, vegetation.

He has a tube to excrete urine to a portaloo.

She will nurse the eggs for weeks in this preferred wetland.

He can see into private lives from up here, the parties, the alone, the scared & the happy.

When she moults, she will be flightless for weeks.

They don't know he's watching them, making up stories to keep him company.

She will feed her young for 70 days.

He sometimes films his vast view to entertain friends & his earlier toddler, The Hilton, from above.

She will commute between roosts.

He will commune in slow motion with another 64 lonely crane tower drivers

in the sky above Manchester.

She will dance the symbol of a thousand years & eternal youth.

This collective construction, this dance above the city, this sedge, this siege, this swoop of cranes

Red-eyed in the night sky, keeping watch over the city.

Hale-Bopp

By Victoria Gatehouse

We lurched out of some pub in Salford
into a grey expanse of car park —

mizzled-on tarmac, the reflections
of streetlights, wallowing

in puddles and that reek of vomit
as we passed the bins.

I can't remember the names
of the friends I drank with back then,

only that we hung on to each other
as we contemplated

all that glitter and spin. We *knew*
it was nothing more than a tail of dust,

the debris trail of something long-spent,
yet never-to-be-forgotten,

the sky above Manchester that night,
beaten to a thin gleam as if

some brawny Northern god
had hammered a path to the stars.

NORTHERN SPIRIT

The Ladies, Manchester Victoria

By Victoria Gatehouse

A mirror-full of women, washing hands
under taps that gush too hot,
the half-steam faces
of commuters in trainers and suits,
of shoppers, of mothers, of kids lifted
to dangle sticky fingers

of girls making ready for the town,
arching over basins,
filling in brows, glossing lips,
hair cracking electric
as they bend double to brush,
rising up in a glimmer of hairspray -
a momentary halo

to distract from the buckling queue,
cubicle doors hanging open
on the blocked, the broken-locked.

When my turn comes, I rest my bag
on a deep-ledged window seat,
picture those who've perched there
in the early hours -

short-skirted, thighs cold

against the tiles, bellies warmed

by the rich melt of chip barms,

the air buzzing

with gossip from the clubs.

And before the last train

slides in to carry them home,

a message scratched out

in eyeliner -

I'm ratted as I write this…

I can reach out and trace

the dark stripes of a bee, the teetering

lines of its wings -

the messages of hope

they've left on the back of toilet doors,

these mighty girls, clattering

in and out of this place,

raising arms, holding each other up.

The Ritz

By Vicky Morris

Manchester, circa 1991

Sometimes you think of *The Ritz* on a Monday night.
£1 in and a watery, free pint, the trampoline dancefloor vibrating
along to each set. First punk, then goth, indie, rock, grunge.

You think of the soap-spiked Mohicans, the nose-ringed
crusties with dreads, the powder-white faces and black macs
draped in corners. The DJ in his box taking requests.

The time you saw Terry Christian off the TV looking out
over the balcony in the smoke and patchouli haze. And all those
spaced-out hippies, with long-since proper jobs, dropping

microdots and purple ohms in the sticky basement chillout zone.
And if, out the blue, the opening riff to the Pixie's Debaser
comes on the radio, you know you'll forget what it is to remember,

find yourself back there running, army-booted and tie-dyed
into the low-lying dry ice of the ballroom bounce, leaving
your lived-in body, and all these years behind you.

Before The Village

By Sarah Pritchard

After *The Gaslight*

decades before *The Village*

I smelt your Welcome

to Coming Out

200 hundred miles away.

Our village gathered

down back streets

in cellars

in back rooms behind back rooms.

We entered *The Exit Club*

& were entranced on poppers

fought like schoolgirls in Swithins

then our closeted police sisters were warning us about a police raid

when married women told families they were out playing Bingo.

We got bold & out n out at *Polytechnical*

Gay student disco on Aytoun Street

We cringed in *Dickens* at voyeurs sitting like straight couples on the edge of the dance floor.

Cabareted at *Follies*, sang karaoke at *Monroe's*

Had a third floor Women's floor at *Paradise*

& gradually crept closer & closer to Bloom Street & Canal Street & the Red Light district.

Our pink village seemed to spring up

out back against Clause 28, AIDS & Thatcher years

like a rush of blossom on a bright new day

sprinkling confetti on a big, gay wedding.

Arrival

By Elizabeth Gibson

Once, a little fish swam across a wide, warm sea

'till it came upon an island, with a beehive, bright and pretty.

The fish so longed to stay there, to know this honeyed city,

that it flopped out of the water, and dressed up as a bee.

It came to love the colours, the sweetness and the buzzing,

and knew that it belonged here, for what it lacked in history,

it made up with its wisdom, from the ocean and its mystery

and when it felt alone, in its mind the waves were hushing.

Over time the fish got braver, let its silver scales start shining,

to form a new mosaic with its black and golden fur

and, daring to believe it could be true to both its worlds,

this new critter relaxed, spread its wings and started climbing.

There was still some doubt there though, 'till the night when you told me:

"But…you're a Mancunian!" – so casually, and so free.

A version of "Arrival" was previously published by Queers of Manchester on their Facebook and Instagram.

My Tribe

By Jan Berry

After the bombing at the Ariana Grande concert in Manchester Arena 2017

"It's my tribe."

Atrocities happen across the world

villages bombed, children killed

torture and genocide.

But now it comes close

to the streets of my city

to the cathedral at its heart

to my bookshop, closed and cordoned off

to where my friend gets the tram

This is my tribe.

I'd never heard of Ariana Grande

the young star whose music

enchanted children and teens

now joined in headlines

with bombs and terror.

I didn't know of the concert

a magnet to fans across the nation.

But now Facebook images flash across my screen

indelibly tattooed on my being.

This is my tribe.

Public tears overflow

fill the streets and squares

waves of grief in flowers and bees.

I want to keep vigil.

I struggle to find words for prayer.

I want to walk the streets

and gather up the fragments of loss.

But I go on with the routine of my daily life,

tension weighing me down.

This is my tribe.

Another concert.

The music plays.

A school choir sings.

A policeman dances.

A young girl soars over the rainbow.

Hope rises.

This is my tribe.

Rain

By Lemn Sissay

w	f	t	n	w	t	r	w	r	i	c
h	a		c		r		e			u
e	l	a		h		a		a	t	
n		l	h		i		t		s	n
t	l		e	e		i	h	i		
h		k	s		u		i	n	t	i
	s			n	m	n	n	b		a
e	t		t		p		k		h	n
r	h	o	e	t	h	f		o	e	
	e	f		h	a		o			
a		m	r		n	a		w		
i	y		b	e			f		M	w
		a	u		t	l		s	a	
n			t			l				a
						s			n	y

'Rain' is placed on the side of Gemini Café at the corner of Dilworth Street and Oxford Rd in Manchester.

Rain is written in the style of Concrete Poetry by the concrete poets of 1950's.

Lunch Hour - Sackville Gardens

By Cheryl Pearson

A break from staplers and plate-glass windows,
from strip-lighting and recycled air. This park is where
a butterfly landed, once, on my shoulder. Where spiders
string the benches together to a soundtrack of ringtones

and double-deckers. Once, I saw a parrot here,
a dozen smart-phones raised to capture
its cracked beak and jungle colours. Once, a sober news crew
reporting a murder. I sit on the bench with the bronze man

who loved numbers and other men, who broke the codes
that helped end a war. Today, two sparrows ruffle the dust
by his frozen trousers. Life goes on, but we remember.
City of cotton and architecture, city of millstone

and super-computer. I walk from my lunch hour on old bones,
file my papers, raise my purchase orders. Each act a small stone
in a giant wall. Outside, the window-cleaner whistles on his ropes;
recalls, inch by inch, the shine from the skyline.

Manchester Tram

By Alicia Fitton

A poem in many voices

Out of the dark at six a.m.

Twin headlamps lit to bear us in,

To struggle through the day's commute

> *Get on the tram mate*
>
> *Get on the tram!*
>
> > > *No!*
>
> *Get on the tram*

Our hair, our skin, our coats, our boots,

Are flags of pride, so rainbow-cute

They say this city's crammed.

> > I cycle slowly through the park
> >
> > Through muddied grass that's partied hard.
>
> I walked the leather from my feet,
>
> The wrong way down John Dalton Street

We trundle fast on tracks beneath

A sky that swoops and swirls to lift

> On towerblocks and orange cranes,
>
> On empty shells where no one lives,
>
> > On driving, sleeting, stairrod rain
> >
> > That drowns our fears and soaks our shame

They say this city's wet.

We clatter through industrial past

Where science stained the brickwork dark

Lowry white, metallic bright,

Those plains of space no longer sit.

The layers stacked and jostle tight.

With geometry and human sweat

The glimmered gilt of architects

We sprawl at the foot of mighty Urbis

Brawl in the lap of Piccadilly!

Collections for the masses yet,

They say this city's grim.

Bronze Emmeline now reaches out

She begs us to consider how

Art for arts sake

Politics for fuck's sake

Retail chains to hold us down

Brave women stood and shouted loud

And people marched, would not be cowed

By men on horses trampling down

We rise, we rose, our colours proud

Echoes with the clink of glasses

Gothic stones in tawny brown.

They say Manchester's grey

But I see the bright spark at its heart

It opens with a warm embrace

Shouts *"Here I am! So now keep pace."*

We say this city's loud!

Praise for the evening commute

By Cheryl Pearson

Oxford Rd, Manchester

Praise the blue, cantankerous buses
boating into their great bays, letting
out passengers and flatulent hisses.
Praise the faltering sun on the *Greggs,*
the *Wetherspoons,* the red-brick clock —
selah! Praise the mums with their prams
and nappy bags, packed to weather
a local apocalypse. Praise the roofers,
the scaffolders, those yellow-jacketed
birds overhead. Praise the student flats
they're raising, the accumulation
of windows - yes, there will be Blossom
Hill and contraband candles there —
selah! Praise the workers in suits
and trainers, praise the university
buildings that rise in the morning light
like bread, and sink again in the evenings —
selah! Praise the *Deliveroo* drivers,
angels in visors blessing the suburbs
with swaddled tikkas and *KFC* — selah!
Praise the lorries beeping in and out
rear-first, the florists rolling tin shutters.
Praise it all — rush hour traffic, pigeon-
shit, and vodka shots - selah! Selah!

*NB: "Selah" is a word used 74 times in the Hebrew Bible, predominantly in the Book of Psalms. Though the original defini-
tion of the word remains unknown, scholars have suggested it was likely used to mean something like, "So be it", or "Always".*

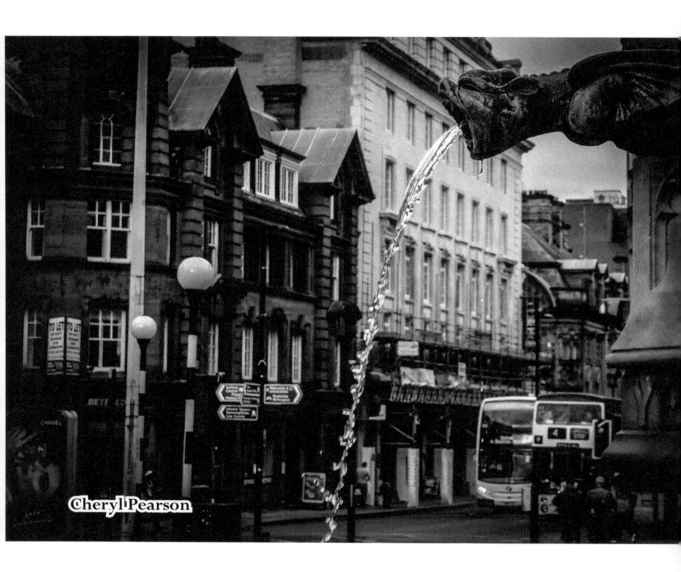

Cheryl Pearson

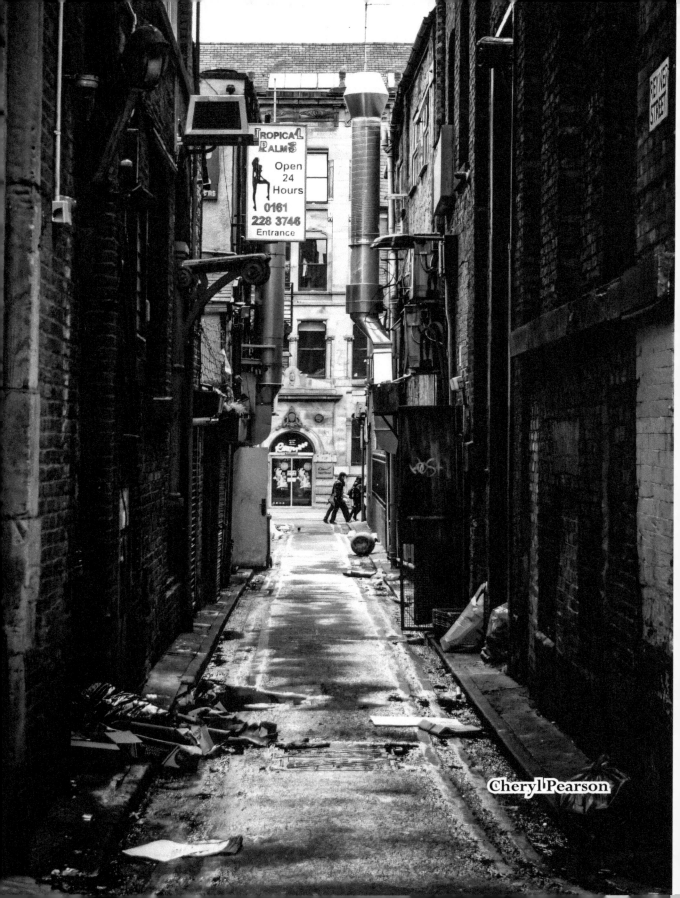

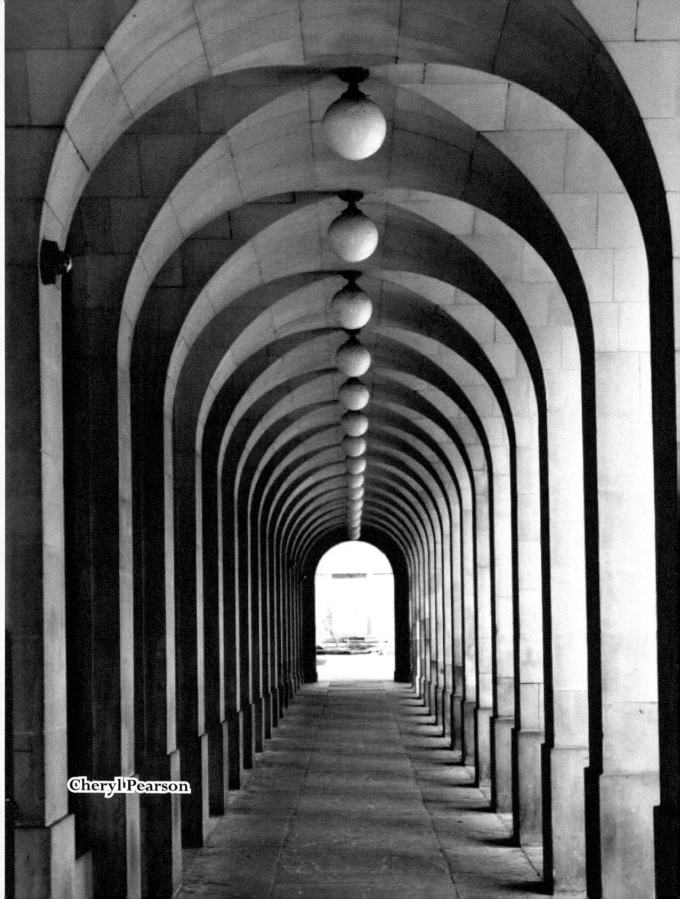
Cheryl Pearson

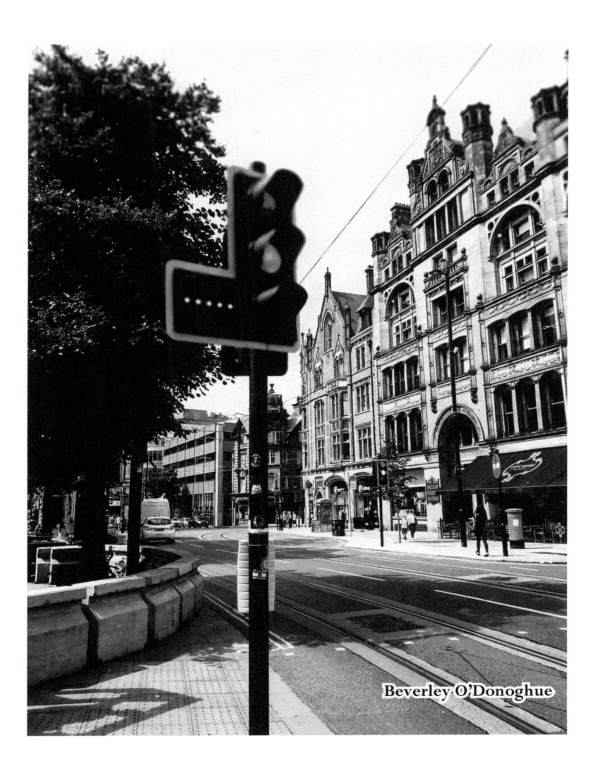

Beverley O'Donoghue

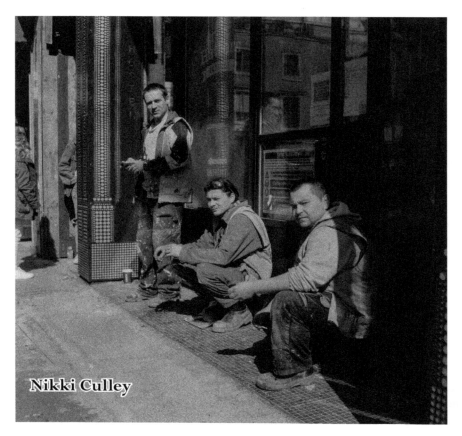

Nikki Culley

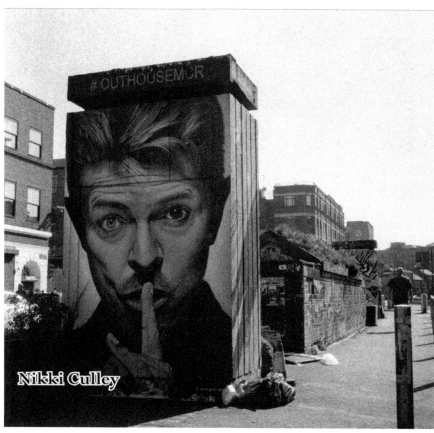

Nikki Culley

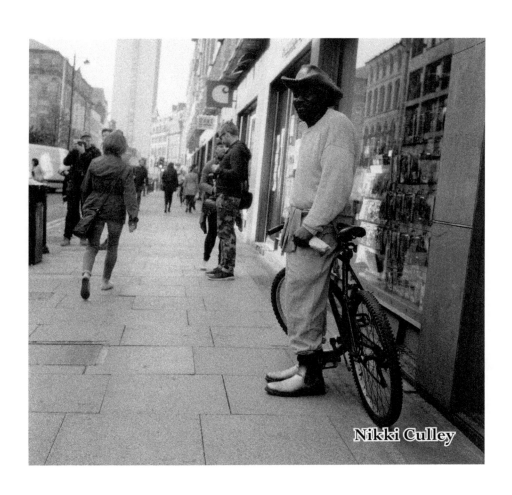

Nikki Culley

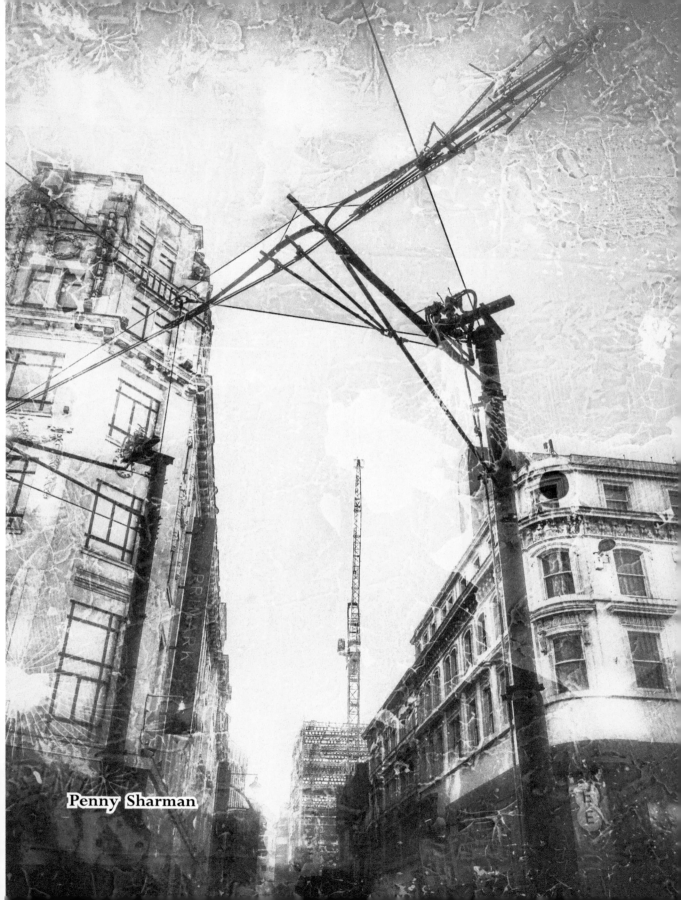
Penny Sharman

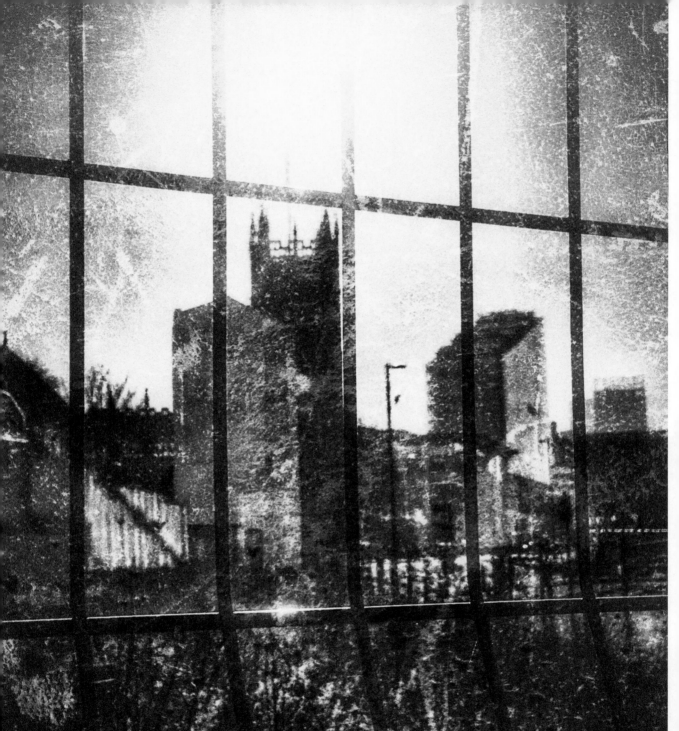

Penny Sharman

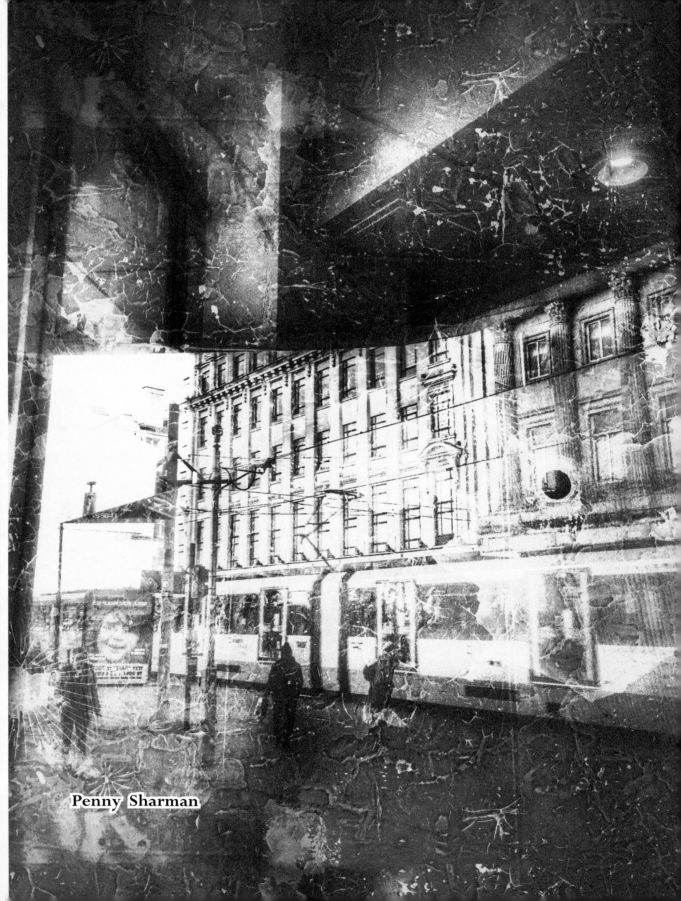

Penny Sharman

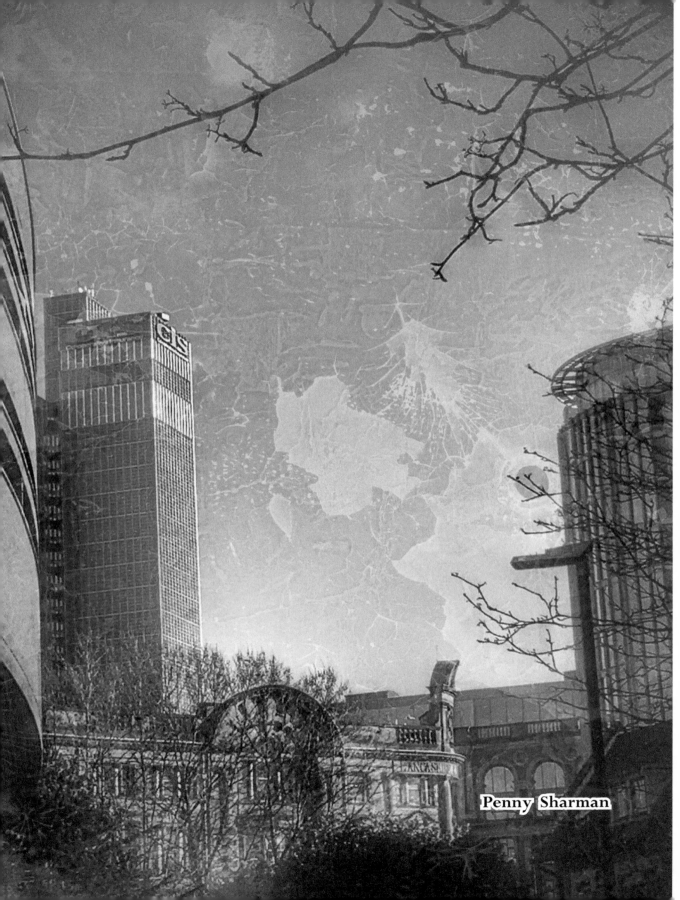

Penny Sharman

Lisa O'Hare

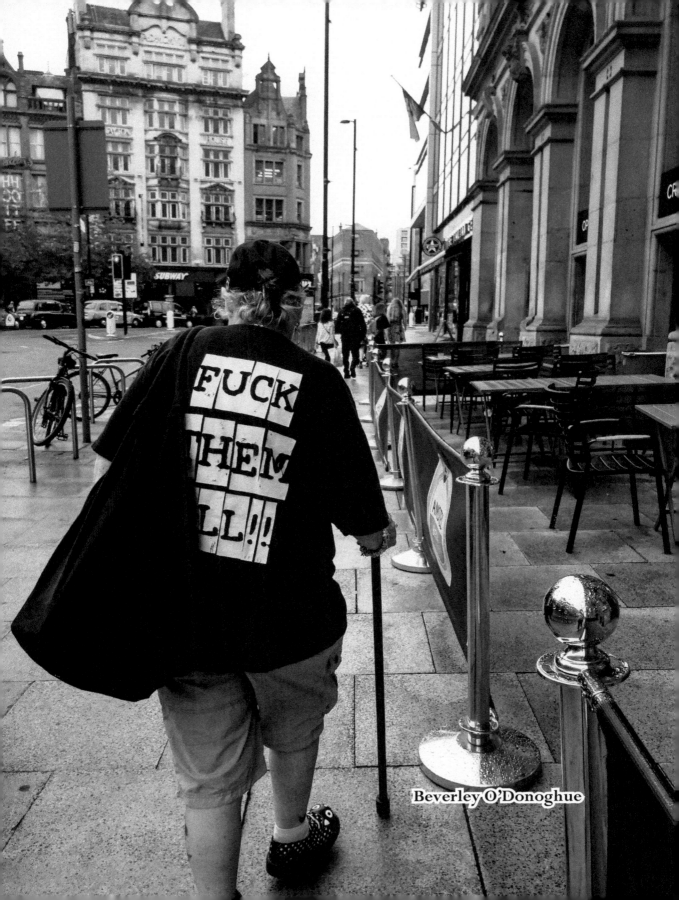

Beverley O'Donoghue

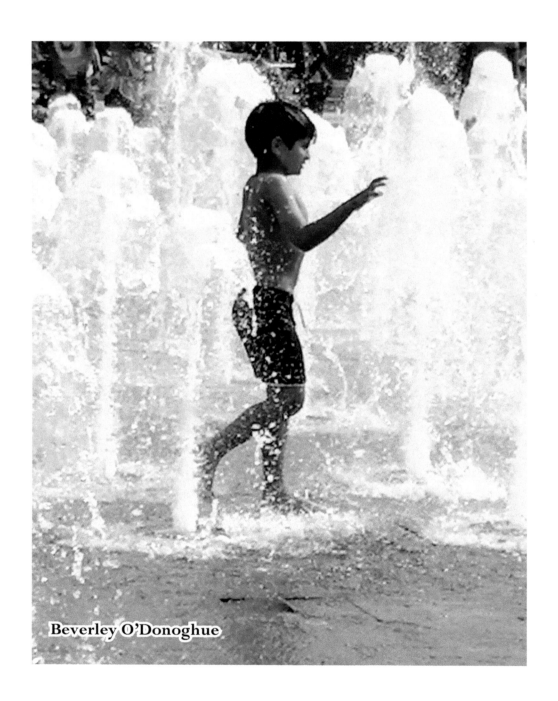

Beverley O'Donoghue

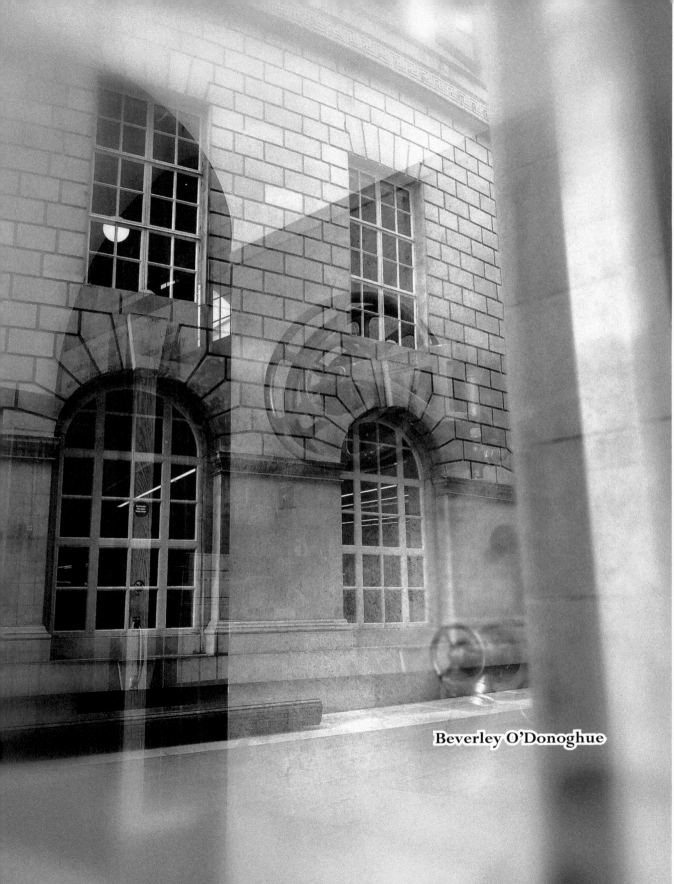

Beverley O'Donoghue

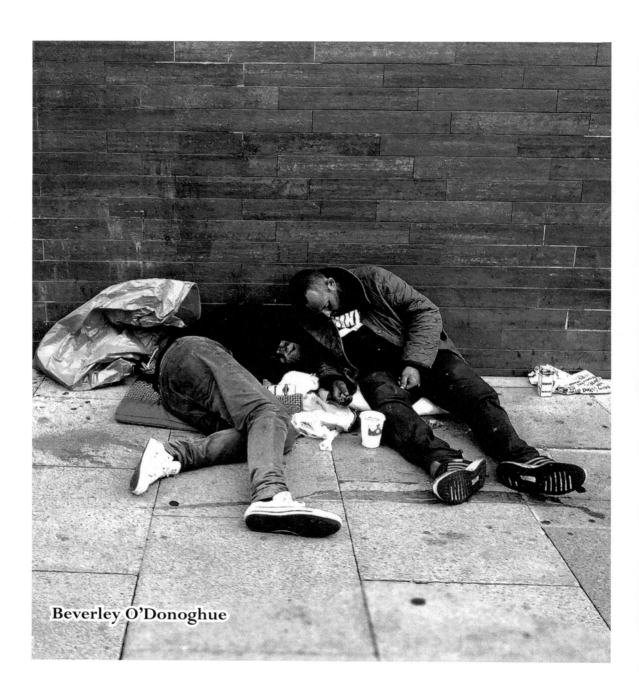

Beverley O'Donoghue

MANCUNIAN HISTORY

The spirit of Manchester

By Estelle Price

So long ago I've almost forgotten who I was
when timber from a ship first formed my ribs.
A draper's shop, I'm told, full of pins and needles,
ladies who bustled in from the Shambles to get away
from meat that dripped bloody mess into the street.

In those hazy early years, I gave birth to a poet.
There's a plaque on a wall that proclaims it.
Byrom his name (such a shame it wasn't Lord Byron)
Who remembers John Byrom, a masonic mystic
who scribbled words into squiggles, invented

shorthand? It's not exactly *Don Juan*.
Even so, it wasn't long before I had a vocation.
I've been the *Vintners Arms*, the *Kenyon Vaults* and at last
the *Old Wellington*, with carthorses bringing barrels
of beer, a seat for the regular who didn't speak

for twenty years, while upstairs an optician
fiddled with lenses and dirty ears. It's true it's not
always been bliss. There was the Christmas Blitz when bombs
fell like coins out of a drunk's pocket, buildings blazed
and I prayed the missiles would skip me.

And then, in the seventies, men in bland suits
filled the air in Market Square with concrete. I believed
they were going to kill me. Instead, they raised my body
on stilts, drove a road through my bowels, built blocks
of shops till grey was the only colour in the vicinity.

For twenty years my bars thronged, drinks slopped,
laughter stirred into anger (such skimpy clothes they wore,
even in winter) until one morning with windows full of sleep,
an explosion wobbled my rafters, brought dust screaming
into my lungs. After all I'd seen I refused

to choke on terror. The men in suits returned, waved
a planner's wand. Brick by brick, slates labelled with blue paint
they cradled me from the blast to the cathedral's shadows.
And there you'll still find me, creaky and skew-whiff
pouring the strong spirit of Manchester into your glass.

Before The Dual Carriage Way

By Tina Tamsho-Thomas

Before the dual carriageway,
Moss Side was a closely-knit
community; doors open, cups of sugar
borrowed on trust, repaid in kind.

Before the dual carriageway,
children were minded communally,
ran in and out of each other's houses,
neighbourly disputes resolved amicably,
grievances settled…eventually.

Before the dual carriageway,
Denmark Road Market flourished,
stalls packed with the latest sixties fashions
attracted shoppers from miles around;
Sunny Tan tights swirled gently in the breeze.

Before the dual carriageway,
Black businesses thrived; friends congregated in
Black-owned restaurants, cafés, pubs and clubs;
danced around the clock to smoky reggae, soul,
jazz and blues.

Reno, Nile, Lagos Lagoona
attracted luminaries *Muhammed Ali, Nina Simone*
and a mythologised visit by *Brother Malcolm X.*

When *Manchester City Council* drove the
dual carriageway through *Princess Road*,
Moss Side's closely-knit community was divided,
dispersed. Neighbours' doors no longer open.

i.m. Sunny Lowry

By Cheryl Pearson

Ethel "Sunny" Lowry was the first British woman to swim the English Channel. She trained with her sister at the now derelict swimming baths in Levenshulme, Manchester, just a few doors down from the house where I live.

What did you love, apart from the water?
Fish on Fridays; the local shop gave you

pale corsets you forked to falling, storms
of salt. Perhaps, you loved Christmas - stars,

smart spruce, and foiled soaps. And yes,
the pool. Its clean lines, implacable ceilings,

the hours rowing tile so clean you could see
the future: French beach; strange light.

Did you love onions? Parakeets? Love
or justify your thighs? Just a century shy

of neighbours; I would have had you round
for wine. Now the rooms you knew are holes,

the brickwork rife with summer lilac.
And you, I'm sure, haunt the communal bins:

I sense you there when I'm ditching beer cans
or pizza boxes, breasting the heavy air for the stars.

Tony Wilson's Dream

By Benjamin Cassidy

Opened May in '82, he'd built it; oh, they came,

saw the world within, setting everyone ablaze

Closed down June '97: lives never to be the same

Atmosphere caught, made vision of the dream,

at first called flight of fancy – just a passing craze

Opened May '82, Tony Wilson built on it. More, more came!

Never profiting financially, it stayed a crazy scheme

The dance remained; cash vaporised. The heady haze

closed down, June '97. A world made not to stay the same

Manchester, again, soared back to global fame

The beating heart of the party, sparking wild ways

Opened May '82, cemented now; from afar they came

Baggy-trousers, tie-dye T-shirts, that soon established theme

Ravers drinking, dancing, revelling nights into days

Closed down, June '97. No place could ever do the same

A funhouse made, this church to music changed the game

Though the night out's done, the place posh flats, the song stays, always

Opened May '82, Tony Wilson's dream: he built; they came

Closed down, June '97. His Disciples keep his Haçienda's flame

The Blanket Bundle and the Marsh Gas Man
By Kathy Zwick

Yarn loops straight up and down the loom,
it stands tight
and waits
and waits and waits
as the slow-moving weft sorts it way
fumbling over and under, painstakingly,
slowly, slowly across the placid warp
until one day, young Master Kay
invents, then improves his slinky gadget.
It shuttles, it speeds. With alacrity it zips
along its long, long horizontal channel,
it flies.

But,
thanks and rewards were slow,
kerfuffles loomed,
spinners were pressured, weavers
felt threatened.
Protests and riots ensued.

Churly thugs intimidate.
Smashing, thrashing mobs invade.

The pet pug yowls
as tiny daughters cringe with fright,
as Dad escapes into the eerie night.
Ignominiously bundled into the hollows

of a blanket,
ingloriously spirited off across the channel.

He waits and waits
for patent-justice and a little fame,
and maybe fortune,
he who jump-started Manchester's fortunes
dies abroad, is buried in an unmarked grave.

The timid, erudite Quaker, without
a formal education, queried and questioned,
inspected, observed, and listened.
He experimented and calculated and postulated.
He bundled his long hollow cane
into his gadget bag, exuberant upon finding
a stagnant marshy pool with an oily telltale film,
and settled down to extract and examine
the bubbly water.

The more bubbles the better.

The quiet intellectual in 1808 develops
and publishes his findings. He jump-starts
investigations into molecular structure
and he waits and waits for full recognition,
suffers a stroke - and then another.

He dies alone.

A long, long century later, in 1908,

Manchester and the world recognise him

as the undisputed dad of atomic theory.

John Kay (1704 - 1780) - John Dalton (1766 — 1844)

Both men were selected for their contributions to Manchester's history when Ford Maddox Ford

created his Manchester Murals and painted them between 1879 and 1893.

Suffragette Tree

By Marie Naughton

Behind Alexandra Park's
　iron railings we find
　　the landmark – this lopped
　　　sycamore twenty foot tall,
　　　alive still, tilting
　　　against the avenue. We pick
　　　a careful path
　　　　through excrement,
　　　　mottled leaves, crisp bags
　　　to squint
　　　at the woody testament –
　　　Nell backs up to it,
　　　　grimacing for the camera:
　　　　she plants a Converse trainer
　　　　each side of the trunk's
　　　　green velvet skirt
　　　　and leans against the gnarled bark,
　　　　raising a fist in the air.
　　　The carvings frame
　　　her sloping body: *Votes* –
　　　a halo above her head –
　　　　For Women
　　　　flanks the left side
　　　　of her face and Mrs Pankhurst
　　　　forges forward, shoulder
　　　　to Nell's right shoulder.
　　　Whippy shoots
　　　　sprout out of the stump like hairs
　　　from an old woman's chin.
　　　　Buds look set to erupt in spring.

NORTHERN GRIT

Spiced

By Rod Whitworth

It's like an island in St Peter's Square,

the tram stop where I wait and look towards

the colonnade. A man lies supine there

and not a single passerby affords

him help. I leave the platform, lean to speak

Are you OK, mate? Eyes as blank as stone

look up. I tap nine double nine. They're quick

to answer. Then, while I'm still on the phone,

a uniform — Police Support — arrives,

says, *Stop that call. I see this every day.*

He'll soon be up. Two ticks. The man revives,

springs up and shakes his head; he's wide awake.

He strides — yes, strides — across the square, mind fixed

on means to get from this hour to the next.

Standard Fare

By Linda Goulden

From a tram seat and a touch screen, somewhere
between the Gardens and St. Peter's Square,
a woman in a raincoat looks up, half-aware.

Outside the closed library, in half-shadow,
two men, half-hidden, sit below
an overhang, between the pillars of the Portico.

Someone stands, obscuring half her view,
but something passed between the two
and one falls heavily, strobed blue

by someone else's ambulance, slewed, slow,
caught between the Bank and Caffe Nero,
sirening rivers of pedestrian flow.

On Mosley Street and further down the line,
as *reasons to ignore* rehearse, refine,
her fingers stumble over *999*.

Between the tramway and the airport train,
the signal cut. No need to try again.
After three stops, a body feels no pain.

Standard Fare was first published by Magma Poetry in the Street edition.

City Tour

By David Keyworth

I didn't tell the city guide
that I couldn't recall the bomb.
It must have been on the news,
the day of England *v* Scotland, Euro 96,
Gazza's overhead chip then shot
hitting the back of the net.

Switching streams, wrong turn after wrong turn,
found myself at Cathedral Gardens,
the Urbis Centre, an exhibition called:
'*Every cloud . . .*'
Glass shattered, no-one died.

Urbis became the National Football Museum,
trams mutated from white to yellow.
Cornerhouse became HOME
near what was the *Hacienda*.

Post-bomb regeneration: *Sinclair's Oyster House*
moved to New Cathedral Street,
taken apart, rebuilt, brick by brick.

It was such a nice sunny day

By Estelle Price

I wish the British Government every success in finding and bringing to justice those responsible
(President Clinton 15 June 1996, in response to the Manchester bombing by the IRA)

you've got one hour I can hardly believe it now they were still carrying on as normal
I don't want to die because someone wants to finish their pizza

we were thinking of getting it towed away just another hoax

it won't go off the biggest bang ever a mighty boom

the wedding car lifted off the floor

orange glass powder it was quite beautiful, it glittered the line went dead

children with us shards of glass

people were so shocked they were running into walls

we were an hour late but the registrar married us

a mannequin hanging out of a window like a dead body

no way we could get back to Bury a bride and groom running towards me

she is heavily pregnant but the baby's heart is still beating

we sincerely regret the injuries to civilians which occurred

as we stepped outside Crumpsall station we could see people mowing their lawns

what bomb? a miracle no one was killed

much more aware of what could happen after that

I think it's very unlikely that you'll see convictions for the Manchester bomb of 1996

I'm alive, we all are

(Found poem sources: BBC; Manchester Evening News; New York Times; The Guardian; Detonation: Rebirth of a City by Ray King; Bury Times; Independent; Government Publishing Office; Irish Times)

23_05_2017

By David Keyworth

On Tuesday morning
after the bomb
Great Ancoats Street and Swan Street
were closed to traffic,
so the birds on Oak Street
could hear themselves singing –
as if someone had decided to start the day again.

Something in the water

By Rosie Garland

She falls as rain.

Nourishes slow, sure and stubborn earth;

perfect for revolution to root,

grow hardy and withstand hungry winter.

Chill clay: unshakeable harbour for odd women

who hold up half this cloudburst sky;

raised on a diet of nothing, plates empty

unless we roll up sleeves and sweat.

Tall from getting off our knees,

backs strong from the schooling

in how hard that is to do.

Mouths strong from saying *no. No more.*

She falls as rain.

She is persistent, bolshy and sarcastic.

Writes soaking stories on slate roofs,

lifts us to the attic to eavesdrop her secrets,

translate her pattering Morse,

decode the truths she whispers,

pass the tales from sister to brother.

She falls as rain

into hands cupped to receive her.

Quenches the ink of Gaskell, Bronte,

Delaney, Duffy, Engels, Turing, Winterson, Kay.

Nurtures dragon tongues to howl

rebel words that speak against the easy grain.

She falls as rain.

Sweeps her torrential swirl of petticoats,

shakes the heavens with diamond lightning,

roars storms loud enough to drown out hate.

She falls as rain.

Teaches patience of the long game, long-haul, long way round.

Patience to pass through granite without destruction

in a peaceful occupation of the planet.

She falls as rain

on all who choose to step from gutter into light,

and like the struggle, she is never done.

Patient as ocean and with the ocean

we wax and wane. Fall and rise. Fall and rise again.

Rise as fountains.

Cast skyhooks into storm clouds,

reel in the rainbow and plant its pot of gold

in every backyard, every street.

Stretch the bow and shelter the city

with a sky conjuring every colour.

This purple, white and green city

stained with Peterloo crimson,

the black and gold of worker bees

steeped in grime and honey.

Sweetness with a tart sting

hard fought for, hard won.

Strength

to be knocked down.

Strength to get back up again, again.

Strength not in adversity but in resistance.

We are built-this-proud, fought-for-this-proud,

we stand-together-proud.

Net us: we pour through the spaces,

chain us: we freeze and crack shackles,

jail us: we melt through bars and under doors.

Shout triumphs, honour wounds.

Flex muscle built from standing up for rights.

Take up space. Break silence, break the peace,

scrawl gobby ink across the page,

rock the sand-banked boat, haul anchor and set sail

off the safe and narrow, off the dotted line,

out of the margins into a new geography.

Manchester music in all its clanging cacophony

of can-do, will-do,

screw-you-if-you-say-we-can't-do.

Why blunt a keen edge in lazy silk

when we can march in mighty cotton?

Spit on hands, leap off pedestals, stick out necks and elbows,

and stride the streets, shoulder to shoulder.

Roll up umbrellas, peel back hoods,

tip up chins and let her wash us dirty,

gift us with grit in the oyster,

burst into peacock pearls.

'Something in the water' was commissioned for Womens' Writes Manchester 2018, & published in The Suffragette
magazine.

The Portico

By Victoria Gatehouse

There was rain on the pavements
the first time I gazed up
at the Greek revival columns,

that day a side door opened
discreetly, onto narrow stairs
and I climbed to a place

of pale arches and cool radiance,
crowned by a plaster dome,
polished and hushed as a church,

a space bound by closed pages –
where strong Northern voices
could be read and heard.

And I would come back to this –
the quietness of the unfound,
that deep glint of mahogany,

shadowy towers of books
leaking their sweet, musky scent
into panelled side-rooms,

a lamp lending its soft light

as I turn the pages on a lifetime's work —

the list Roget compiled, indexed,

wrestled with and classified,

the ordering of which kept him sane.

In here, we might find the words

we need, and in finding them,

assign the demons

to the smallest corners of our lives.

the war of each against all, is here openly declared (engels)

By burn

salford survivor, mary burns
opened engels' eyes to workers
and those unable even to …
edgelands-incendiarist / witty-inferno
truth-burns love-rages engels into
'free union' for life & across cottonopolises
1840s pages of working-*slash*-underclasses
how much is learned? how much earned?!

'provoked to madness by the brutality of wealth'
hives-line seizing us in an early 2000's hostel,
after 'support-workers' *'what dya need books for*
yr homeless?' & us burning to read 'em wrong
across thirteen years, lucky for some graduating
open uni n open degree - heart-attacked 'n 3 year back
has nothing been learned? we've learned –
& that with love's raging, much can be turned.

NORTHERN CULTURE

It takes a woman to know a woman

By Estelle Price

Manchester Art Gallery collection of sculptures

When the lights go out, Widow wakes,
rustles the adamantine pins that project from every square
of her full-length frock.

She carries a woman's grief in her black, leather skin
glints as she glides her loss —
unable ever to be touched — across
the polished floor in search of Venus Victrix

who, at Widow's command, drops the golden apple
balanced in her marble hand. *For who needs an apple*
to establish value? Widow asks Venus,
asks the same of Eve. Naked Eve, who huddles on a plinth
arms shielding her body as if her breasts
are brimming with crimson shame.

On another floor, Iphigenia bows her head
waits without complaint for a father's sword to enter
her ribs, not even stony eyes permitted to resist.
Come, says Widow, *it doesn't have to be like this.*

She leads her women through the halls, until she finds
the Reader, seated on a chair, rosettes on her shoes,
book half-open, only a smile to suggest what she is thinking.
Follow me, says Widow, *it's time to untie your opinion.*

Even the warrior, Boadicea, Widow rouses.

Boadicea who has no spear or chariot,

whose arms are placed about her daughters' shoulders

as if they take an evening stroll around the city.

We need your fury, Widow says, *not this bizarre conformity*.

The six look from a barred window onto Mosley Street.

Nearby, in St Peter's Square, a women in a bronze jacket

stands on a chair, arm outstretched, protest spills from open mouth

There are no apples, her head is unbowed.

Even without words her call to rise is loud.

She is Emmeline, says Widow, *sculpted from torment*

by the hands of a woman. Like me.

Sculptures referenced: Widow by Susie MacMurray; Venus Victrix by Holme Cardwell; Eve by Auguste Rodin; Iphigenia in Aulis by Alexander J Leslie; The Reader by Jules Dalou; Boadicea by James Havard Thomas; Emmeline Pankhurst by Hazel Reeves.

Eighth Day Café

By Sarah L Dixon

My chlorine hair and my resolve to eat well
after a kilometre breast-stroke, bring me to this place
like a friendly, sparsely-lit school canteen.

I write with water-wrinkled fingers
under the table,
watch as people interact in the old way.

A "student" highlights text with orange marker
to match his hair and the patches on his jumper
that I suspect are not a fashion statement.

Dominic Berry should echo from the walls,
and be reflected in the tables
as Manchester's Premier gay, vegan poet.

There was a time he was at every event
I stood and quivered at,
and I wish I bought a ticket for "Wizard".
I miss his overblown actions
and his genuine pleasure at seeing a familiar face.

As I taste the faint lentil
of Aduki beans in my tomato soup
I hear him recite, "Tomorrow, I WILL go dancing!"

As I finish my beetroot and hummus roll

and drain my organic apple juice

I crave sex, chocolate and deep-fried chicken

am tempted to upturn the sea-salt onto my tongue,

stuff my mouth with butter pats.

I crave the *kerdinck* of Twitter and BBM.

A noisy, dancing group of eight staff

enjoy a group hug and their smiles infect me

I leave carrying a smile

and the faint scent of Aduki beans

to St Peter's Square tram-stop.

Photograph of Lowry at Home

By Ruth Taaffe

By the edge of the open door
brass-hooked trilbies crown the coats
emptied of the man. Further back,

concealed by easels, he's figuring
from his chair, paintbrush raised
as in farewell

retiring in a crumpled
three-piece suit. Gutted frames
prepared like kindling

wait for some fire. On the mantel piece
the carriage clock ticks
this time forever.

Sounds imported from up north

By Sam Rose

Come on, buggerlugs
Mum cajoles, *the sun's*
cracking the flags out
there but I have never
been a morning person or
an outside person or —

— It's spitting as
we walk to school,
through the ginnel one
house down — fine in
daylight, creepy when
night hides the graffiti —

— Back home
Make us a brew, eh, cock?
Aye, 'ere y'are.
Do you want a biscuit or anything
to tide you over until tea?
Nah, nowt —

— *Bleedin' Nora!* dad
shouts as he bangs his
head on the cupboard
what a pillock —

— Homework help
at the kitchen table
I see, said the blind man
Dad says when I claim
to understand something that's
obviously clear as mud to me —

— Fast-forward to adulthood,
I call my partner buggerlugs
tell my friend to stop mithering
but will 'e heck as like?
They look at me bewildered —
we are a midlands mob
southern subjects
else they would say *yer wot?*
Yer barmpot! I'd be well chuffed
if they did.

Oh ManchestOH

By Fiona Boylan

I was born in one of ten boroughs of Greater Manchester

In a fair old town called Bury

They like black pudding in these strange lands and I can count on my hand the

different names they'd use to describe a bread roll

'*Do you want a cob, bap, bun, muffin or barm,*' this is all part of Manchester's charm

My mother despaired the day me and my sister started school and these local kids

defied every rule of the English dictionary.

Whatever the ending of a name, the notes would always sound the same and I

became known as *Fionoh* and I learn't to speak *propoh* dead good like and go with

'angin' boys who gave me a backy on their bike, on the streets of Salford.

This city gave me balls, to rival any man's. I never felt second rate or too afraid to

take a stand. And challenge the status quo, and be able to show there's a fire

burning inside, like the brave Emmeline Pankhurst, who was born in Moss Side,

where I spent my teenage years.

So, join me for a day whilst I show you the sights. We'll get lost in Affleck's Palace

where you can get anything from cyber gear to legal highs. They've got the world's

biggest flavoured johnny shop, playing records that make you wanna bop as you

peruse the jewellery and grinders and more. But we can't stay long, so let's bounce

and hop and walk the streets admiring Akse 19'S work, you'll be in awe. Next, let's

catch a matinee at the Royal Exchange, just wait till you see the inside of this

building, look up, it's insane, and afterwards we'll sit outside on Roman ruins for a

tipple in Castlefield. Do you fancy going further afield and checking out an

exhibition at The Whitworth, getting a curry on the mile, see a band at Heaton Park

and then, once it gets dark, head onto a club in the Northern Quarter, for a bit of drunk and disorder? Dance to New Order. Before I treat you to chips with gravy.

I'm proud of these northern shores, in a town which, seventy years ago, opened the hospital doors of its first NHS. It's where I've raised one baby and gone on to have another. This is the decision I have made as a mother, to have my children be raised amongst their Mancunian sisters and brothers and tell me of their mint time playing out with their mates and I'll meet them at the school gates and they'll ask me, do I have any scran and they swear down Mam, they've not been causing any mither.

And what future do I see for these babies in this post-Industrial town? I'm proud of its mixed cultural heritages and opportunities for all.
We unite in the face of hatred, strengthen our defences, stand tall. That'll surely be my Taste of Honey, in this Cottonopolis, with my babies by my side.

And with a northern man, they keep you on your toes, have a certain Manc swagger, humour very tongue in cheek. We like to drink in the Northern Quarter, Chorlton, Prestwich or see a gig at the Apollo at the end of the working week, with a load of our mates.

Yes, this is Manchester and we do things a bit differently around here. We talk like no one is listening and we love to chew one's ear. Our fair city has stood the test of time. A medley of music, football, cobbled streets, Oasis, Lowry, Morrissey, Turing, Rolls meeting Royce, Dalton, Rutherford and sunshiiiiiiiiiiine. And it'll keep on growing and creating greats and surviving and thriving and staying alive. She'll carry on through it all, she's a waterfall.

After Lowry: 'Laying a Foundation Stone' (1936)
By Ruth Aylett

Now then, it's not funny you know,

a serious matter is laying a foundation stone;

a put-on-the-best-hat occasion, a line up the children

and stop-yer-fidgeting occasion. That means you, George.

Can't help those flags, the Fete Committee

should have washed them; but we've thon great Union one.

Of course we're patriotic. Yes, in or out of work,

(just keep quiet then, Frank, stick to your pipe)

and shoo those flaming dogs before they do something

as they shouldn't. Shush, councillor's arrived.

Such well-chosen words. Education is vital,

prepare them kids for a great future,

peace and prosperity in their time.

Now then, it's not funny you know.

Bubble gum pavements

By Mark Andrew Heathcote

City pigeons make street art under Manchester bridges

A Jackson Pollock, something organic.

It could be Mural, 1950s and look—here?

"A bubble-gum pavement", is this urban street art?

The pointillist canvas; does it mimic the universe

And all that's still to comet through there?

I love all kinds of art, but a dead carcass

In formaldehyde stretches that to the limit.

I'd rather see some burnt-out wreckage

A car, where no-one got hurt or died.

I'd rather see pigeon excrement

Than a human anatomy, artist

Using someone's once-living flesh and bone,

I'd rather see bubble-gum pavements

Then see this great, new modernistic art of nothing at all.

Central Library

By Susan Sollazzi

Our own
Pantheon gleams whitely,
its portico offering a grand welcome
to the reader. Inside the vast entrance hall is
no less splendid, with shields and crests of the great
and the good. Stained glass scenes from Shakespearean
plays underline our scholarly purpose here; so too the marble
statue of the pensive Reading Girl who greets us on our way
upstairs to the resounding glory of the Great Hall. Intimidated
by polished shelves of venerable tomes, dwarfed beneath
the magnificent dome, we barely dare to breathe aloud,
for each whisper will echo in circular exuberance to
distract the reader bowed in study, obedient
to the lofty overhead call to wisdom.
Today, we do not enter but
collect outside to
start our
march
against
climate
change,
snaking
forth
in loud
protest,
carrying
banners
of loving
care
for our
planet.

LAST ORDERS

Oxford Rd

By Jackie Hagan

In my tiny factory town I learnt
if you are clever you go to London
and wear a pinstripe suit.
You figure out what everyone else wants
and run as fast as you can towards it.

I was A-star clever when my Dad got A-star sick:
I stayed close to home.
Manchester was red brick and tall.
On Oxford Road I stood in the biggest room
I'd ever been in.
5"2' - I strained to be seen,
smoking rollies in the quad,
trying not to think in my own voice

A-star sick got sicker.
My mum would make us laugh
in the hospital corridors;
the smell of the amputation ward stayed with me.
On the day he died
I was facing the wrong way on Oxford Road.
It was 9/11 and everyone was shook.
Maureen in a salmon coat told me

God laughs at plans. We laughed too hard
together. Manchester gave me
second-hand sequins, turned A-stars
into class As, halfway houses, abandoned homes,
running from dealers who duped us
and soon, I was back in that ward,

the smell I'd kept in my chest
with fear now the norm.
Between amputations I dreamt my teeth fell out
and they did.
I found the way to laugh at this.

Manchester Royal Infirmary restarted my heart.
on Oxford Rd.
A theatre where I had music-halled my drunkenness
told me my truths are real
and the shame at not doing it right
became a storybook.

In Whitworth Park
a mum had a gang of kids
3, 2, 1, go -
three went for the tallest swing
while one ran hard and wrong
towards a bench and sat there beaming.
His mum laughed at how clever he was.

Now there are trains to London
every twenty minutes
and I get the 6.35 with the businessmen.
They look important, like toys kept in the packaging.
I am in pajamas, rainbow hair askew.
A pinstripe man helps me with my wheelchair
and glimpses a smile. I sit in meetings

with platters of fruit
but the train home is always better,
drinking with strangers.
At Oxford Rd station, the lift is broke.
Everyone helps
with my wheelchair and my wine.

Contributor Biographies

Abbie Day is a spoken word poet from Manchester who has been performing her work for six years. She has a degree in English Literature and Creative Writing from the University of Warwick and works as an Editor for British Library Publishing.

Alicia Fitton is a performance poet who has only recently moved to Manchester and still gets giddy about it. She usually writes about lust, guilt and justified feminist rage and her first poetry pamphlet, So Tightly Wound, is available now via Amazon. You can also read more at her website http://www.stormcloudkitty.com

Benjamin Francis Cassidy is a 38-year old aspiring writer, who lives in Longsight, Manchester, with his cat, Lucy. Born in Blackpool, he left to seek his fortunes...he doesn't have much money, but did finally get his degree, from Manchester Metropolitan University, graduating in 2018. Since then, he's attended further writing courses and workshops, resulting in getting published in two anthologies of new writing, from Comma Press. He writes non-fiction, too, regularly contributing to Sci-fi-Pulse website, and Mad Hatter Reviews. Previously he's written for Louder Than War music magazine, MCR Live, Haunt Manchester, and has contributed to various blogs. Recently his reviews of poetry and artwork have been accepted by The Lake and High Window, and are due for publication in summer 2020. Ben runs Seymour Poets, a community poetry group for vulnerable and struggling adults (he counts himself among them!).

Beverley O'Donoghue is a photographer and artist who predominantly creates unique paintings which are inspired by the ever changing skies and the rugged terrain of the Peak District and the majestic mountains set within the rich seasonal landscapes of the Scottish Highlands. She works from her home in the High Peak and paints mostly in acrylics and charcoal but has recently become a lover of oils. Her aim is to translate the memories which are evoked from walking daily, capturing the light, atmosphere and texture of these wild open spaces onto canvas. Not confined to one subject, Beverley also paints animals and still life usually as commissioned pieces.

Billy Morrissey is an 18-year-old poet from Barnsley, South Yorkshire with a special interest in all things Mancunian. She's a member of Hive's poetry collective, and has earned praise from poets such as Mike Garry and JB Barrington. In March 2020, Billy was the headline poet at the After All Festival online, and will be performing at the physical event later in the year. She has been published in the Youth Word Up (Off the Shelf Literature Festival) and Surfing the Twilight (Hive), both in 2019. Billy works as a journalist, which she's going on to study at the University of Salford from autumn 2020.

burn is inventive in finding the gaps/spaces to make and show work, as well as reclaiming spaces for and with other marginalized, silenced people. they use plural as a reflection on their broken mind, though technically they're solo. coming up thru disability arts, they are an artistic associate with the museum of homelessness (another part of their lived experience). waters of life is a performance supported by the society of authors and the authors' foundation and by dao (disability arts online) and will include poetry plus banners, welsh-poppies, sound and participation, collectively exploring mental distress and moments of healing along the life-giving afon wysyg (river usk). This is where they (burn) were first gifted widened horizons, their first punk gig, learnt of the trade in lunacy, spent time under a tree too old to be carbon-dated, and drank coffee where britain's last insurrection to

date took place. burn writes in lower-case only.

Charlotte Murray grew up in West Yorkshire and graduated from the University of Leeds in 2012 with a degree in English and Sociology, followed by a Master's degree in Archives and Records Management from the University of Liverpool. She currently lives in Liverpool and works as a Project Archivist in a museum. As well as writing, she enjoys travel, reading, exploring historical places and hiking in the countryside or by the sea. This is her first published poem.

Cheryl Pearson is the author of two poetry collections ('Oysterlight', Pindrop Press, 2017, and 'Menagerie', The Emma Press, 2020). Her poems have appeared or are forthcoming in publications including The Guardian, Mslexia, Frontier, The Moth, and The Interpreter's House, and she has twice been nominated for a Pushcart Prize. Her short fiction has been published in TSS, Longleaf Review, and Confingo among others, and she was commended in the Costa Short Story Awards in 2017. She lives and writes in Manchester.

Dave Williamson is now a middle-aged Gardener who secretly wrote poems from an early age, but has only recently been launched onto the public. He attends his local poetry circle and reads at events in the Manchester area. His poetry is strongly influenced by his memories and gritty observations of life in the mill towns of the High Peak and evokes emotions of a world he often finds confusing.

David Keyworth has been published in Orbis, South Bank Poetry, Poems for Grenfell Tower (Onslaught Press, 2018) and elsewhere. In 2012 he won the poetry category in Salford University's WriteNorthWest competition and in 2013 a Northern Writers' Awards (New Writing North). He has an MA in Creative Writing from the Manchester Writing School (MMU) and attends the Stockport Write Out Loud group. His debut pamphlet, *The Twilight Shift*, is published by Wild Pressed http://www.wildpressedbooks.com/david-keyworth.html

Elizabeth Gibson is a Manchester-based poet and performer whose work explores issues including identity, body image, city life and nature. She has won a Northern Writers' Award and been shortlisted for the Poetry Business' New Poets Prize. Her writing has appeared in journals such as Cake, Cardiff Review, The Compass, Confingo, Litro and Strix. You can find her on Twitter and Instagram as @Grizonne.

Estelle Price completed an MA in Creative Writing at the University of Manchester in 2016. Previous to that she worked as a lawyer in London and Manchester and ran an international charity with projects in Nairobi, Kenya. Since completing her MA Estelle's poetry has been placed or listed in many competitions including the National Poetry Competition (2019), Bridport Prize (2019), Canterbury Poet of the Year, Much Wenlock, the London Magazine, Yorkmix, Manchester Cathedral, Wells, Bangor, Vers and Welshpool. She was the winner of the 2018 Book of Kells Prize and was shortlisted for the 2020 Mairtin Crawford Award. Poems have appeared in the Paper Swans, Three Drops from a Cauldron and Stony Thursday Book anthologies and the Smith|Doorstep: The Result is What You See Today anthology. Estelle is working on a collection of poems themed around the Bloomsbury Group and also two pamphlets of poems, one linked by the spring bulb, Galanthus, the other by the shifting concept of 'home.'

Fiona Boylan was brought up on the north side of Manchester in Prestwich. She left her city at 18 to go and study Drama and English Literature in Hull. After graduating she went to East 15 Acting School in London to do an MA in Acting. She eventually moved back to her northern roots to raise her two young children. She is a professional actress and voice over artist and on a day she is feeling confident, would describe herself as a spoken word poet. Fiona loves writing what she calls *Little Ditties* - her observations, mumblings, rants and take on the world around her.

Jackie Hagan is an award-winning writer, performer, trainer and activist. She is passionate about class, sexuality, disability and accessibility. She recently starred in and wrote an episode of Crip Tales for BBC Four and BBC America. She has had her shows commissioned and produced by orgnisations such as Unlimited, Graeae, The Royal Exchange, SICK festival, Contact Theatre and Hope Mill Theatre. She has toured globally including performances in Toronto, Rio de Janeiro, New York, Frankfurt and Amsterdam. She has been nominated for a National Diversity Award, a Woman of the World Award for effecting lasting social change. She has written for Attitude magazine, Diva magazine, Gay Star, Big Issue, Topshop and regularly crops up on BBC Radio Four, and BBC Ouch! She is a guest lecturer at Manchester Met university and an accessibility consultant.

Jan Berry lived in Manchester for twenty years, where she worked in theological education at Luther King House in Rusholme. Just under a year ago she moved to Northwich in Cheshire, where she loves the countryside and river walks, but misses the diversity of the city. She lives with her partner, and enjoys creative writing, walking and (when lockdown permits!) circle dancing.

Joseph Darlington is a writer from Manchester. His books *Avon Murray* (2016) and *Spare the Glass Picnic* (2018) are available from www.josefadarlington.co.uk. He is co-editor of the *Manchester Review of Book*s and can be found on Twitter at @Joe_Darlo.

Kathy Zwick has taught Social Studies at an international school in London for over 20 years. Many of her poems develop themes taken from recycled lesson plans and have been published in several UK anthologies. These include The Hippocrates Prize, The Brownsbank Anthology, Hand Luggage Only, In Protest, Ver 2015, Wolverhampton Literary Festival Anthology 2018, Bollocks to Brexit, and Planet in Peril.

Lee Garratt was born in a south Manchester hospital in 1972 to a Wythenshawe dad and a Failsworth mum. He grew up in Rochdale, but most weekends saw him at the Corn Exchange, Piccadilly Records or Maine Road. He became very familar with Manchester Victoria train station! Now an English teacher living in Derby, he writes a variety of poetry and prose, some of which has found its way to print. Recently, a collection of his science fiction work, Other Times, Distant Lands, has been published.

Lemn Sissay Google the name "Lemn Sissay" and all the returning hits will be about him because there is only one Lemn Sissay in the world. Lemn Sissay is a BAFTA nominated award winning writer, international poet, performer playwright, artist and broadcaster. He has read on stage throughout the world: from The Library of Congress in The United States to The University of Addis Ababa, from Singapore to Sri Lanka, Bangalore to Dubai, from Bali to Greenland AND Wigan library. He was awarded an MBE for services to literature by The Queen of England. Along with Chimamanda Ngoze Adichie and Margaret Atwood he won a Pen Pinter Prize in 2019. He is Chancellor of The University of Manchester and an Honorary Doctor from The Universities of Huddersfield, Manchester, Kent and Brunei. He is Dr Dr Dr Dr Lemn Sissay. He was the first poet commissioned to write for the London Olympics and poet of the FA Cup.

Linda Goulden was born Scots, grew up in Manchester and now lives in the High Peak of Derbyshire. Her pamphlet 'Speaking parts' is published by Half Moon Books. Some of her poems have won prizes (e.g. Manchester's Poets and Players) or appeared in magazines (e.g. Magma Poetry), in anthologies, online, on tree trunks or in the repertoire of Whaley Bridge Choir. She is currently collaborating towards a mixed media exhibition.

Lisa O'Hare is based in North West England, where she regularly writes and performs her work at various spoken word events such as Verbose, Testify and Bad Language. During 2020 she has had two of her poems featured on BBC Radio Manchester's Upload hour. She also creates art and more of her art can be found @lisaslockdownart on Instagram. She can also be found on Twitter @Lisaohare_0

Lou Crosby is a poet, printmaker and illustrator. She illustrates poems as comics in a project called Seeing Poetry. Some of her artwork has been used for the covers of poetry magazines and the book Zebra, Ian Humphreys (Nine Arches Press 2019). She has a poem in Dragons of the Prime: Poems about Dinosaurs (Emma Press 2019) and another in Watermarks Anthology, published by Bluemoose Books. Lou lived in Manchester for 12 years and still works in Greater Manchester. She now lives near enough to visit frequently to see friends, gigs and the occasional football match. She runs the Leeds branch of Laydeez do Comics and hopes to set one up in Manchester in the near future. seeingpoetry.com @loupoetrycomics

Marie Naughton's's poems have been published widely in anthologies and magazines including Mslexia, The Dark Horse, Southword and The North. She's lived in Manchester since 1977 and she works as a psychotherapist. *Suffragette Tree* first appeared in her debut collection *A Life, Elsewhere* which was published in 2018 by Pindrop Press.

Mark Andrew Heathcote is from Manchester in the UK, author of "In Perpetuity" and "Back on Earth" two books of poems published by a CTU publishing group ~ Creative Talents Unleashed, Mark is adult learning difficulties support worker, who began writing poetry at an early age at school.

Nikki Culley is a film photographer and dark room printer living in Manchester, UK. She loves working with the grain and texture in film and experimenting with chemical methods of making black and white photographs. Nikki also works with colour film for creative documentary and storytelling work. Website: www.nikkiculley.com

Olivia Walwyn has an MA in Creative Writing (Poetry) from the University of East Anglia. Having worked for some time as a librarian, she is currently based at home with her husband and young daughter, in Macclesfield. Her poems have appeared in a wide range of publications; most recently, *Meniscus, Ink, Sweat and Tears*, and *Orbis*, and anthologies produced by Dempsey and Windle and Half Moon Books. She has a pamphlet, *En Route* (2018), and a first collection *Halcyon,* published by Templar (2019)

Penny Sharman lives in the Pennines just outside of Manchester, but has lived in and around the city since 1968 and has seen it change so much. She believes the heart of the city is still a friend of hers. She is a published Poet, Photographer and Artist. Penny is inspired by many landscapes and the depth of the human heart. Website: pennysharman.co.uk

Peter Viggers gained an MA in Poetry from the Centre of New Writing at the University of Manchester (2016). He is a member of Manchester based 'Poets and Players'. His poems have been shortlisted for: The Bridport Competition, the Anthony Cronin International Poetry Award, Wexford,

Ireland and highly commended in the Brian Dempsey Memorial Poetry Competition (all in 2018). His poems have been published in amongst others: The Best New British and Irish Poets Anthology 2019-21 (Eyewear), SMOKE and Orbis.

Reshma Ruia is an award-winning writer and poet living in Greater Manchester. Her first novel, *'Something Black in the Lentil Soup'*, was described in the Sunday Times as 'a gem of straight-faced comedy.' Her second novel manuscript, *'A Mouthful of Silence'* was shortlisted for the SI Leeds Literary Award. Her writing has appeared in *The Mechanics' Institute Review*, *The Nottingham Review*, *Asia Literary Review*, *Confluence*, *Cabinet of Heed*, *Funny Pearls*, *Fictive Dream*, *The Good Journal*, *Sguardi Diversi* and various anthologies such as *Too Asian Not Asian Enough*, *No Good Deed*, *Love across a Broken Map* and *May We Borrow your Country* among others. Her stories have also been commissioned by and broadcast on BBC Radio 4. Her debut collection of poetry, *'A Dinner Party in the Home Counties,'* won the 2019 Word Masala Award. She is the co-founder of The Whole Kahani writers' collective of British South Asian writers. WWW.RESHMARUIA.COM @RESHMARUIA

Rod Whitworth has lived in or around Manchester all his life and has always worked in the city. His poems have been published in various journals and one of them was highly commended in this year's Poets and Players competition. He lives in Oldham and is still tyrannised by commas.

Rosie Garland: Writer and singer with post-punk band The March Violets, Rosie Garland's work appears in Under the Radar, Spelk, The Rialto, Ellipsis, Butcher's Dog, Longleaf Review, The North and elsewhere. Forthcoming poetry collection 'What Girls do the Dark' (Nine Arches Press) is out in October 2020. Latest novel The Night Brother was described as "a delight…with shades of Angela Carter." (The Times) In 2019, Val McDermid named her one of the UK's most compelling LGBT writers. http://www.rosiegarland.com/ https://twitter.com/rosieauthor

Ruth Aylett teaches and researches computing in Edinburgh. She has published widely in magazines - including The North, Prole, Interpreter's House, Agenda, Envoi, Southbank Poetry - and in a large number of anthologies, including Scotia Extremis and Umbrellas of Edinburgh. She jointly authored the 2016 pamphlet, Handfast (Mother's Milk) and her first single-author pamphlet, Pretty in Pink (4Word), is due out in 2021. For more see http://www.macs.hw.ac.uk/~ruth/writing.html

Ruth Taaffe is from Manchester, UK, and currently lives in Singapore where she works as an English teacher and Head of English. She is taking an MA in Creative Writing with Lancaster University. Some of her poems have been published in the online journals *Creative Writing Ink*, *Nine Muses*, *The Poetry Village*, *Allegro* and in print in *Acumen*.

Sam Rose is a writer from Northamptonshire, UK and the editor of Peeking Cat Poetry Magazine. She is a three times cancer survivor and a PhD student, researching the role of poetry in psycho-oncology. She has had work published in over 50 venues. Find her at https://www.writersam.co.uk and on Twitter @writersamr

Sarah L Dixon lives in Linthwaite, Huddersfield. She and her 9 year old son moved from Chorlton, Manchester on 2017. *Adding wax patterns to Wednesday* was released by Three Drops Press in 2018. Her first book, The sky is cracked, was released by Half Moon Press in 2017. Sarah's inspiration comes from being in and by water and adventures with her son, Frank. http://thequietcompere.co.uk/

Sarah Pritchard has been a member of playback Theatre since 1992 and has been writing & performing in Manchester over 30 years. She is still political & passionate about poetry strolls & poetry en plein air. Published anthologies: Beyond Paradise, The West in Her eyes, Urban Poetry, Nailing the Colours, Manchester Poets Volume3, Bang, Full Moon & Foxglove, Rain Dog, The Grapple AnnualNo.2, Stirred Zines, Picaroon's Deranged & Degenerate Voices on Domestic Violence, One Person's Trash, Bonnie's Crew, cotton appreciation society & Sinister Wisdom. *After The Flood* (a stormy swim through the 1953 floods of East Anglia) finalist in Local Gems' 2017 NaPoWriMo chapbook- 30 poems in 30 days. 2nd collection *when women fly* out in 2019 published by Hidden Voice.

Susan Sollazzi is an author and more latterly a poet, finding an outlet for ideas and strongly held beliefs in the poetic form, She helps run Manchester Women Writers, a nurturing group where writers of all levels can stretch and hone their skills. Her greatest pleasures are in her family, her children and four grandchildren.

Tina Otito Tamsho -Thomas is a published writer, poet, spoken word artist, writer-in residence, playwright, Black Writing Development pioneer and Human Rights Advocate. Her impressive poetry collection *Someone Is Missing Me* is due for publication early 2021 with Fly on the Wall Press. Her unique, forthcoming memoir *Haunted By The Truth* explores Identity, Adolescence and Belonging. 'Compelling story lines…the child's voice is at its absolute best, innocent and comical. Race issues handled beautifully'. The Literary Consultancy. Her *Like Never Before* entry was runner up in the Black Artists On The Move, Virtually Living, International Poetry competition 2020. Her work can be found in several anthologies including: Red: Contemporary Black British Poetry, Sexual Attraction Revealed and Brown Eyes.

Victoria Gatehouse lives in a Pennine village, has a day job in cancer research and an MA in Poetry from Manchester Metropolitan University. She loves writing (and reading) about folklore and myth. Her poems have been published in numerous magazines and she has won the Ilkley, Otley, PENfro and Poetry News competitions. Victoria's pamphlet The Mechanics of Love was a Laureate's Choice for 2019.

Vicky Morris is a poet, editor and creative educator based in Sheffield. She's been published in places like The Rialto, Poetry Wales, Butcher's Dog, The Interpreter's House and Under the Radar. She won first place in the Prole Laureate Competition 2019 and was a runner-up in the Mother's Milk Poetry Prize 19/20. Vicky has built young writers' provision in South Yorkshire for many years, founding Hive in 2016. She won a Northern Writers Award in 2014, and in 2019 The Sarah Nulty Award for Creativity for her impact in the region. Vicky is currently an Arvon/Jerwood mentee. www.vickymorris.co.uk

About *Fly on the Wall Press*

A publisher with a conscience.
Publishing high quality anthologies on pressing issues, chapbooks and poetry products, from exceptional poets around the globe. Founded in 2018 by founding editor, Isabelle Kenyon.

Other publications:

Please Hear What I'm Not Saying
(February 2018. Anthology, profits to Mind.)
Persona Non Grata
(October 2018. Anthology, profits to Shelter and Crisis Aid UK.)
Bad Mommy / Stay Mommy by Elisabeth Horan
The Woman With An Owl Tattoo by Anne Walsh Donnelly
the sea refuses no river by Bethany Rivers
White Light White Peak by Simon Corble
Second Life by Karl Tearney
The Dogs of Humanity by Colin Dardis
Planet in Peril
(September 2019. Anthology, profits to WWF and The Climate Coalition.)
Small Press Publishing: The Dos and Don'ts by Isabelle Kenyon
Alcoholic Betty by Elisabeth Horan
Awakening by Sam Love
Grenade Genie by Tom McColl
House of Weeds by Amy Kean and Jack Wallington
No Home In This World by Kevin Crowe
The Goddess of Macau by Graeme Hall
The Prettyboys of Gangster Town by Martin Grey
The Sound of the Earth Singing to Herself by Ricky Ray

Social Media:

@fly_press (Twitter)
@flyonthewall_poetry (Instagram)
@flyonthewallpoetry (Facebook)
www.flyonthewallpoetry.co.uk

CPSIA information can be obtained
at www.ICGtesting.com
Printed in the USA
BVHW020619290920
589763BV00028B/565

9 781913 211288